How to Draw
Vampires
In Simple Steps

WITHDRAWN

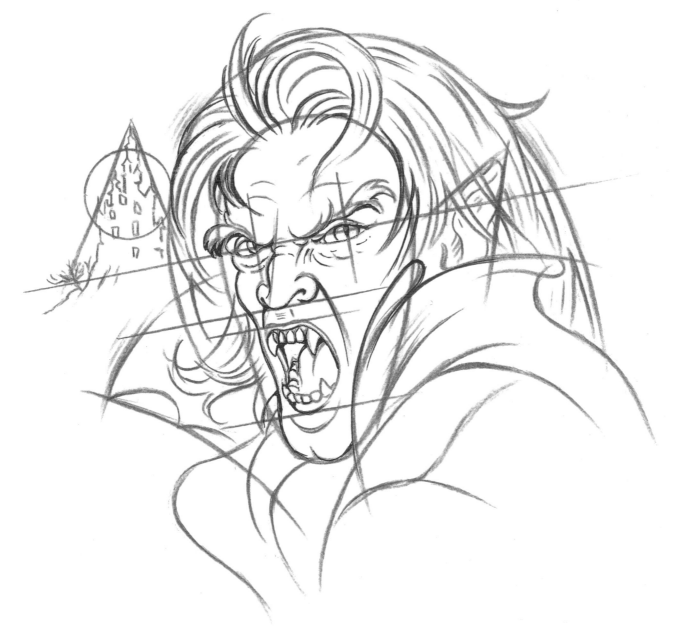

First published in Great Britain 2010

Search Press Limited
Wellwood, North Farm Road,
Tunbridge Wells, Kent TN2 3DR

ISBN: 978-1-84448-640-3

Printed in Malaysia.

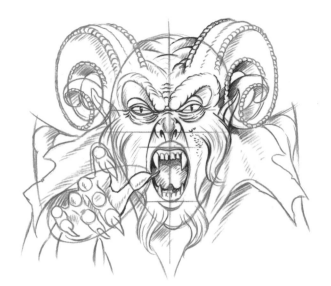

Dedication

For my Dad Lionel, a truly 'Gentle Man'.
Long gone but never forgotten.

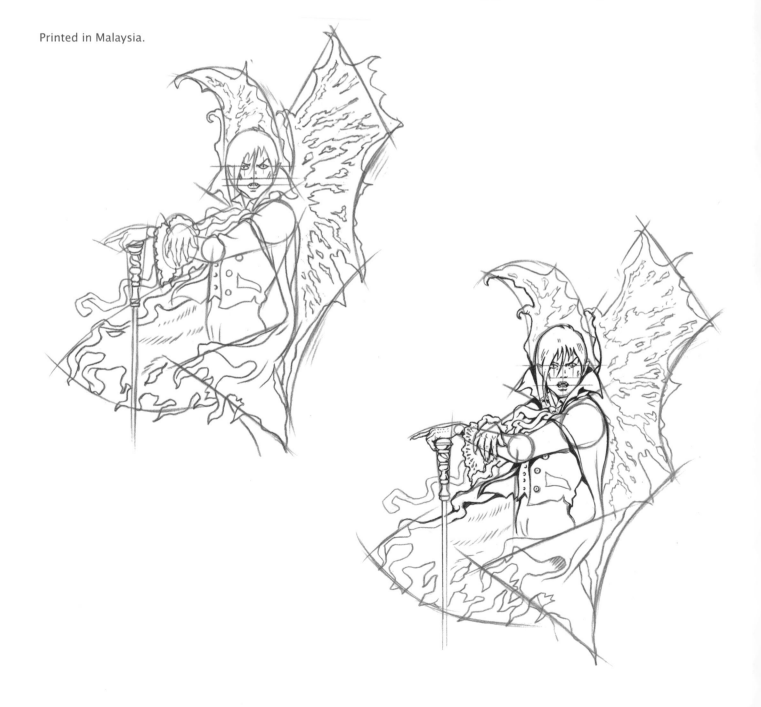

How to Draw
Vampires

In Simple Steps

Paul Bryn Davies

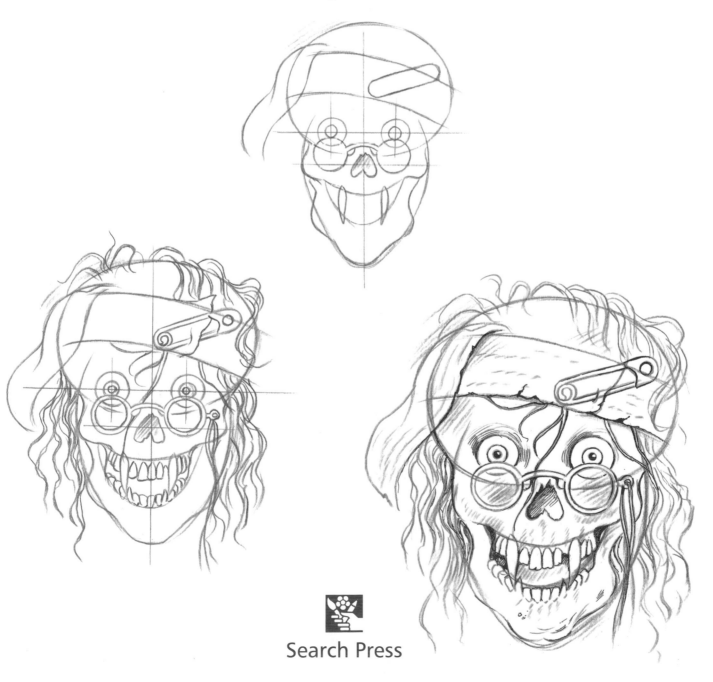

Search Press

Introduction

Welcome to nightfall – the time the Vampires rise to drink. I hope you will find the following pages inspirational as they show you, in easy stages, how to create these most feared creatures of the night. I have included a broad selection of frightening and sometimes beautiful vampires in different styles, both male and female. Younger artists will have fun drawing the cartoon and Manga-style subjects, and to add to the menacing atmosphere I have included bats, tombstones and castles in some of the drawings. A background setting can enhance a character considerably and it does not have to be complicated.

The aim of this book is to encourage aspiring artists to view the vampire figure as a series of simple shapes. Each of the joints, such as shoulders, knees and elbows, can be drawn as ball shapes, while the bones that connect these joints can be seen as simple rods. When the image is broken down into interlinking circles, ovals, etc., the drawing process becomes much easier.

In most of the illustrations I have drawn the main body shapes first, then the images are built up in stages. To make the sequences easy to follow, I start with the colour blue. In subsequent steps I continue to use blue, but change to red when adding new lines or shapes. I use these two colours to show the development of each of the drawings more clearly, but as they are difficult to erase you should use graphite pencil for all the stages.

The best way to start off is to sketch the steps using a fairly soft pencil: HB, B or 2B. Apply the lines softly so that any unwanted marks can be erased easily after each stage is finished. When the image is complete and you are happy with the result, the drawing can be inked in using a technical pen, a fine ballpoint pen or a fine-tipped felt pen. Finally, all pencil lines should be erased.

If you want to add colour, you could use pencil crayons, markers, watercolours or acrylics. Alternatively, if you have the equipment and the skills, your drawings can be scanned into a computer and coloured digitally. I have chosen to use watercolours which have been applied using an airbrush, and opaque white gouache has been added as highlights.

If, after drawing the vampires in this book, you want to create your own compositions, understanding the basics of human anatomy will really help you. It is a good idea to look at photographic reference for the basic figure. Magazines, mail order catalogues or photographs of family and friends are a great source of inspiration – though hopefully not for the fang-like teeth! Break down the body and head shapes as shown here, or use tracing paper if you find it easier. An artist's mannequin is also useful for creating the foundation of your vampire drawing. Seek inspiration for clothing by looking at costumes, both old and new.

Good luck with your drawing and remember – close the windows at night. You never know!

Happy drawing!

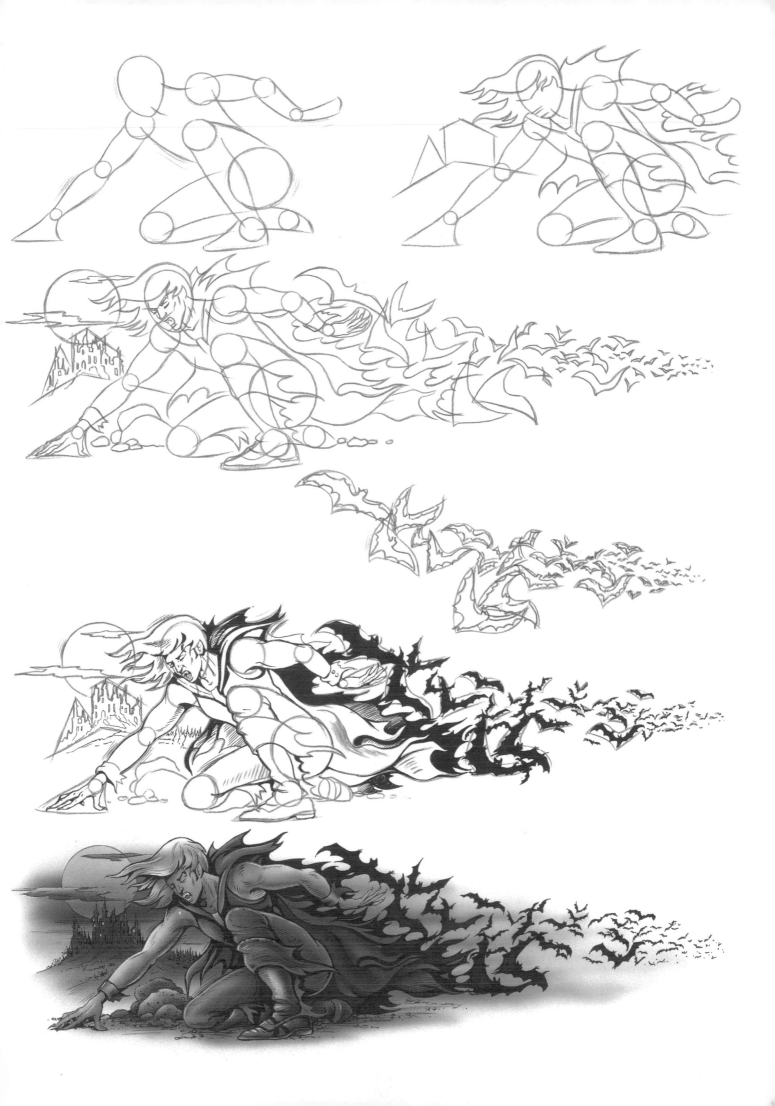

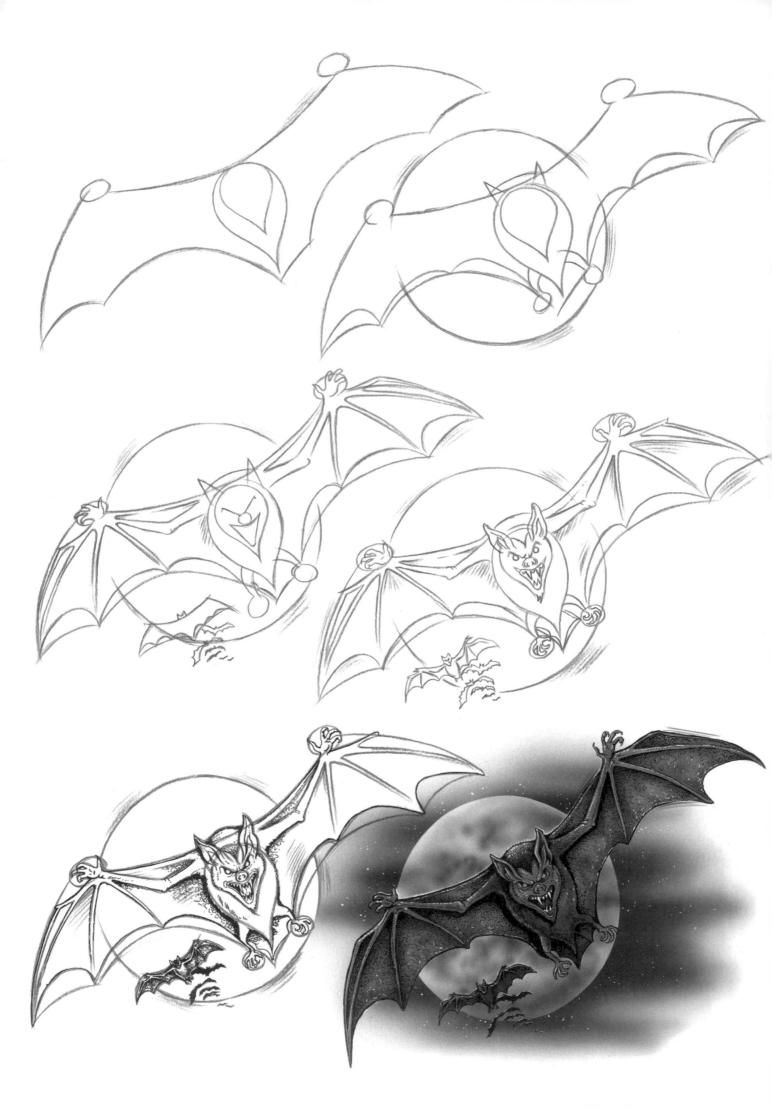

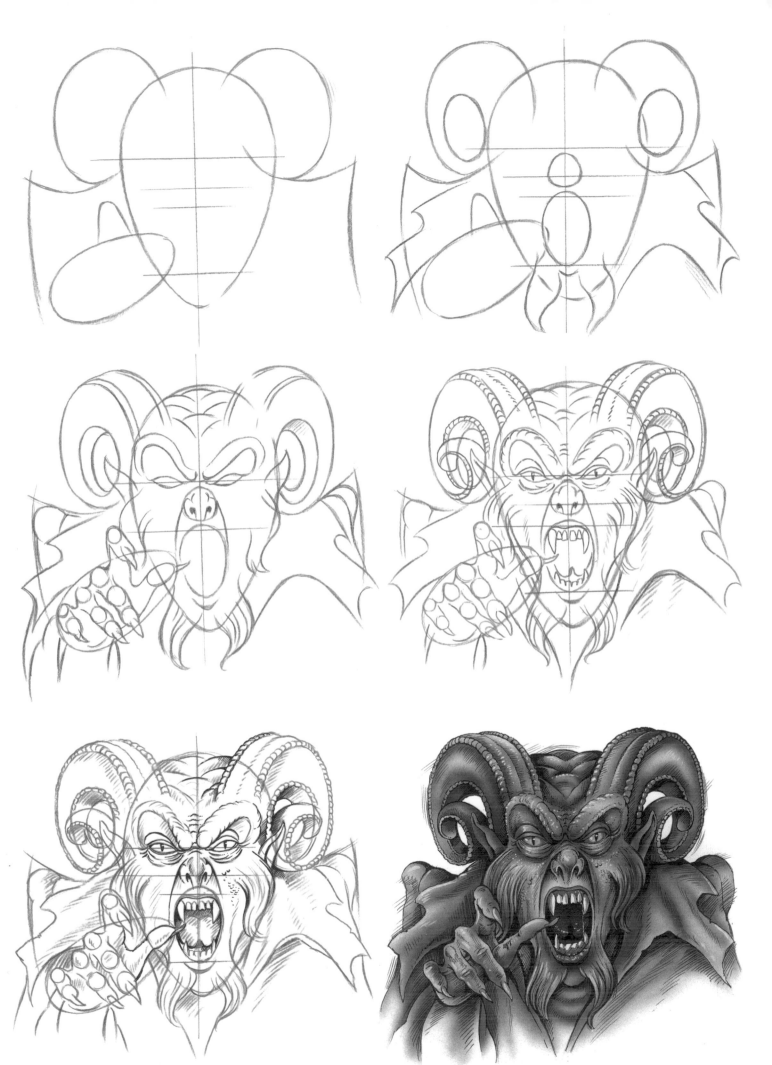

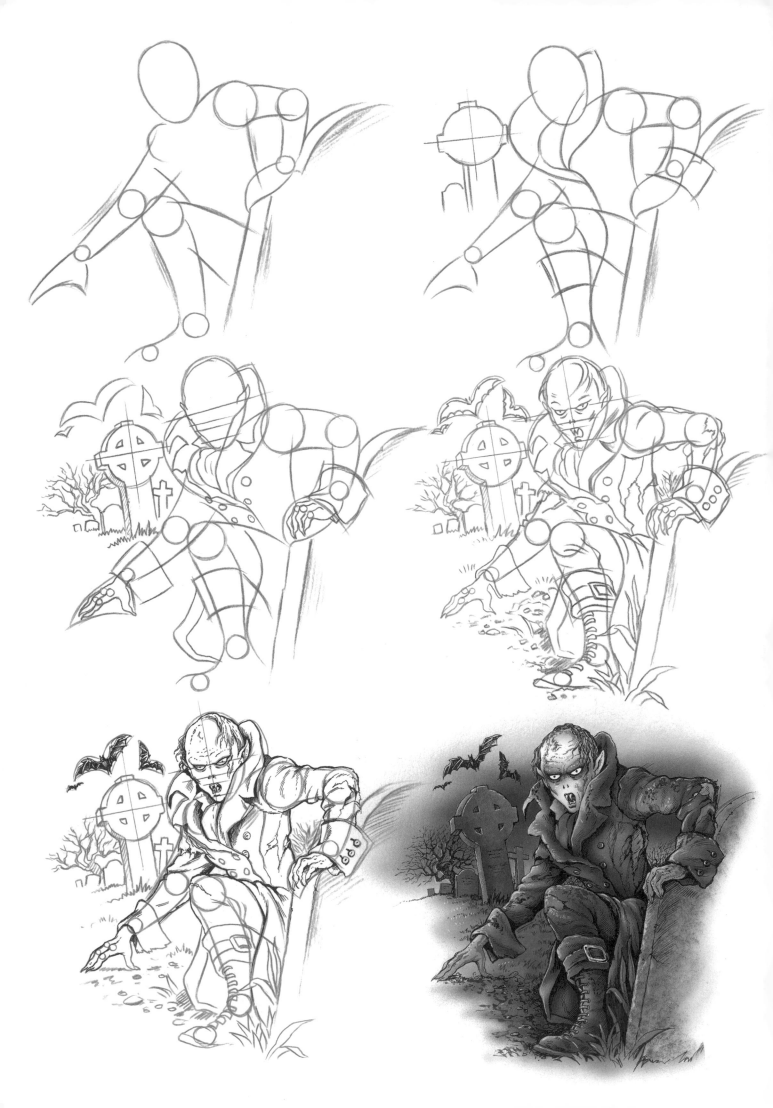

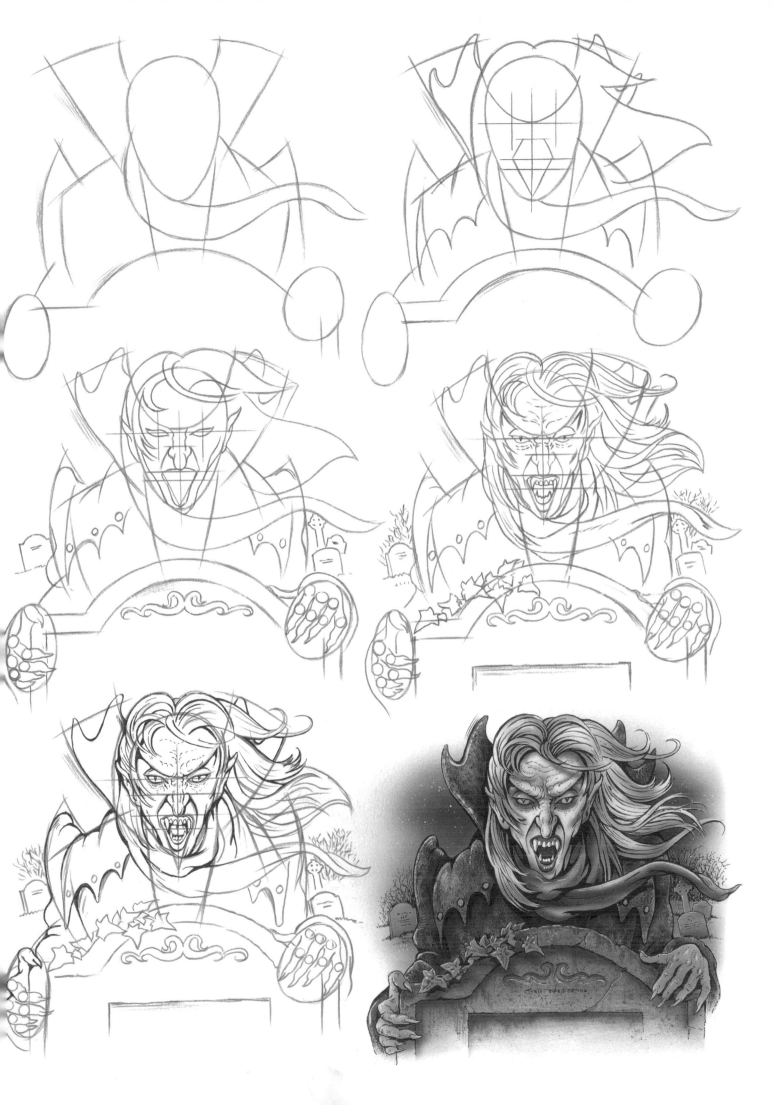

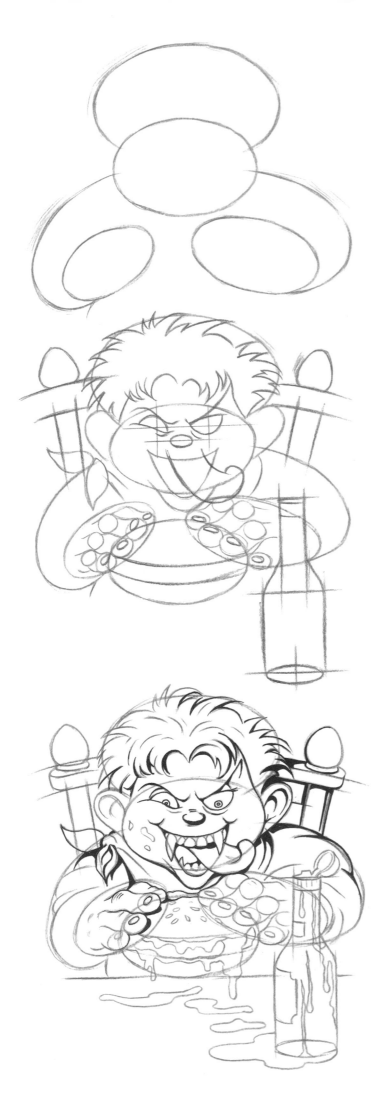
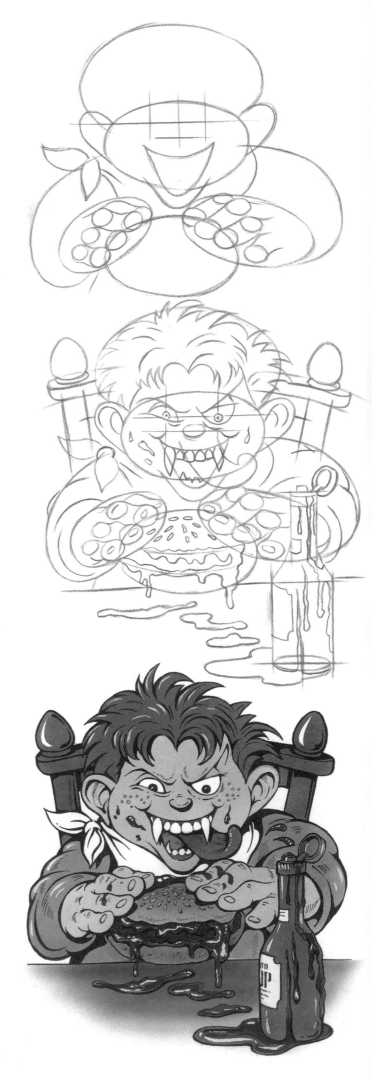

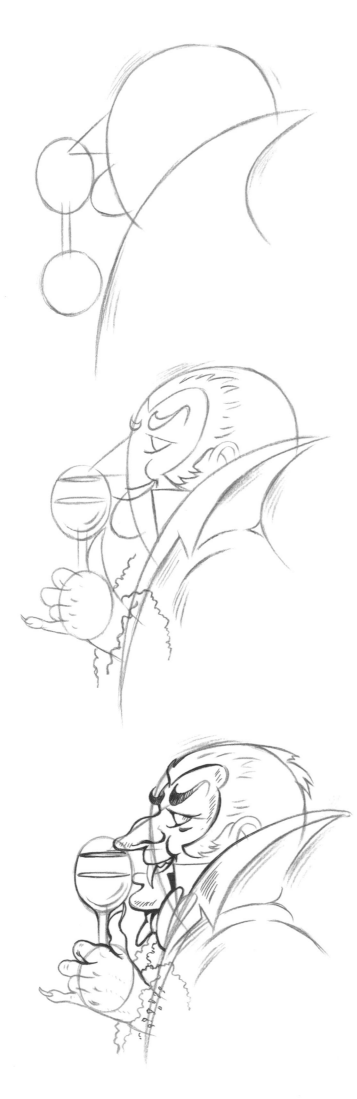
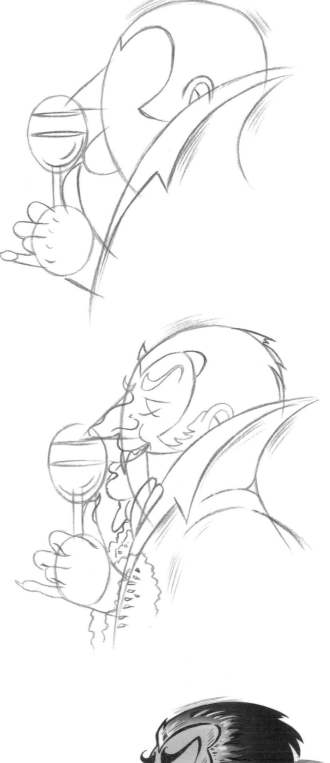
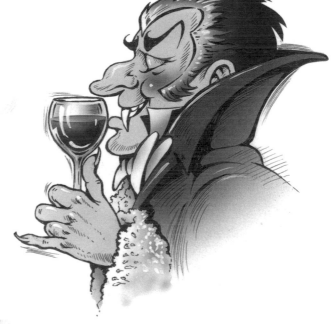

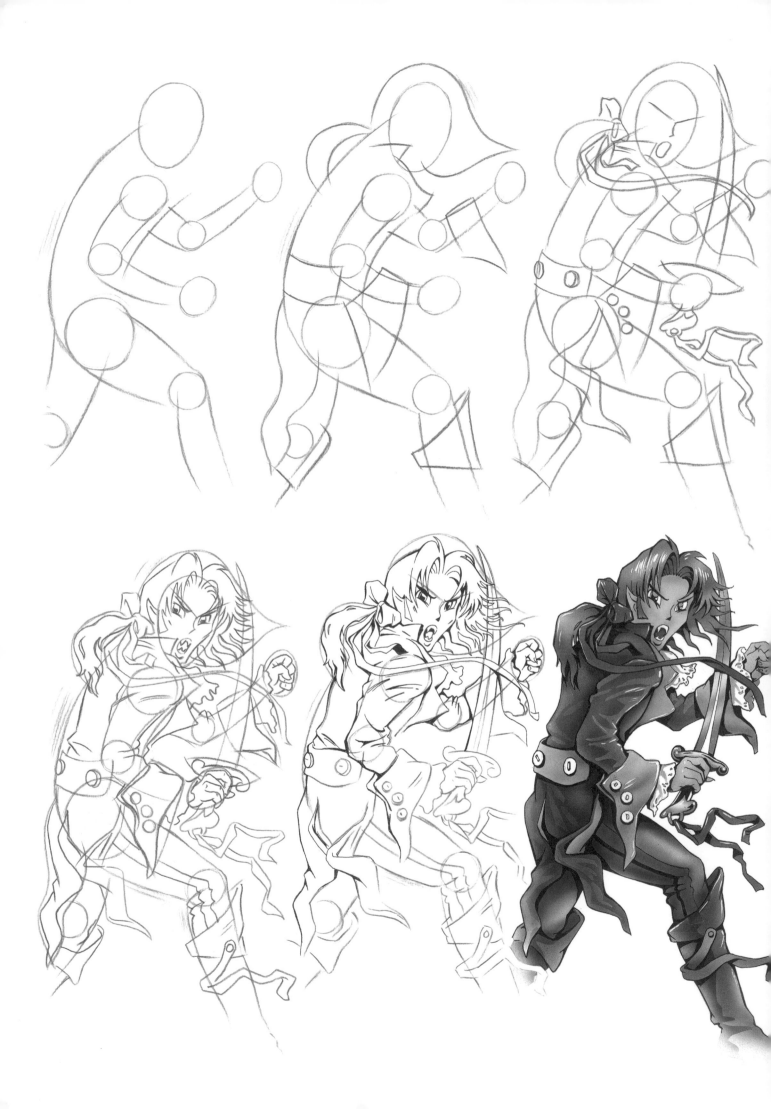

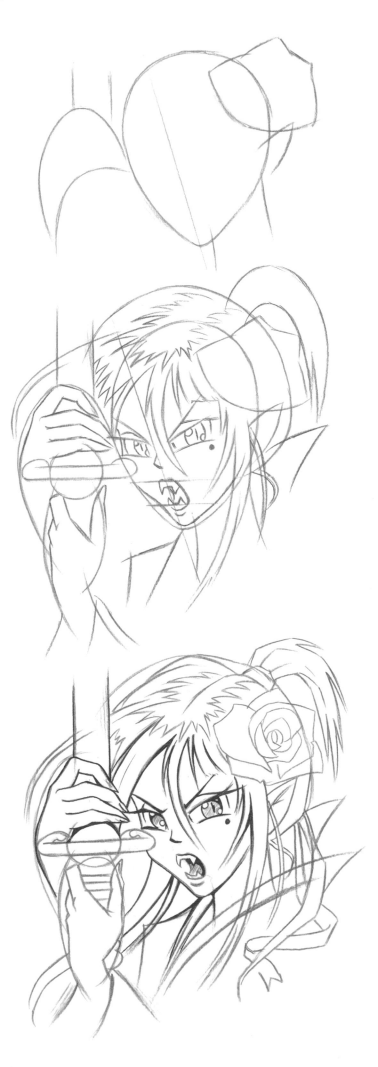
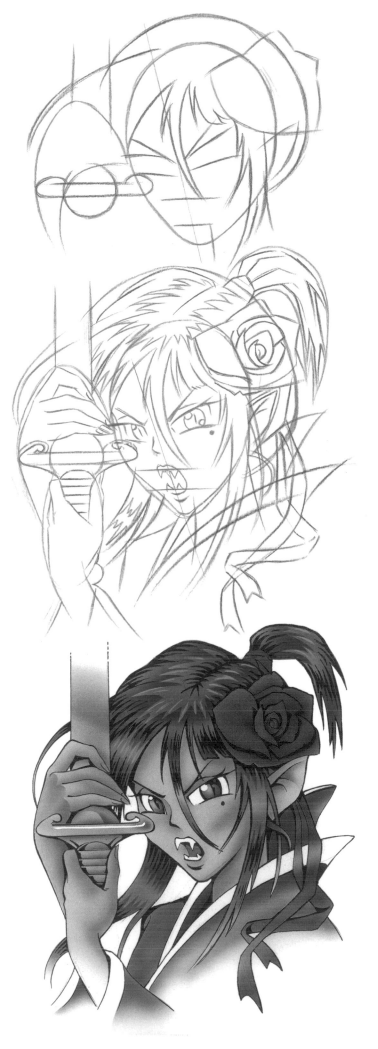

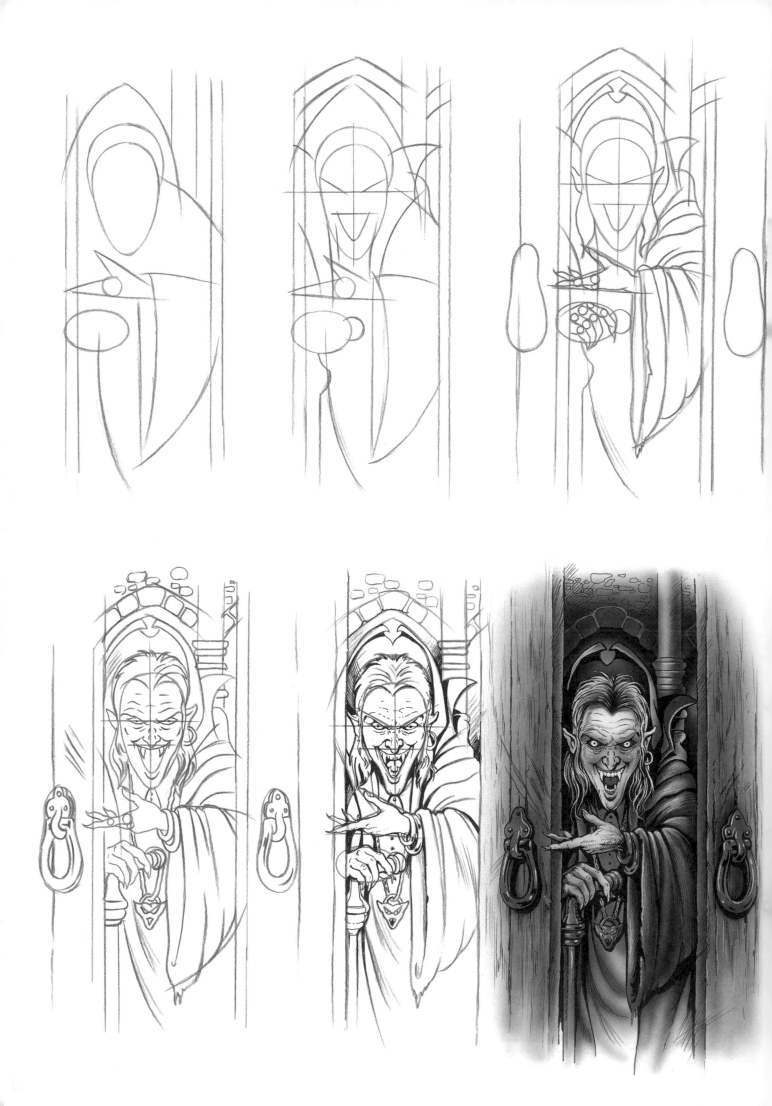

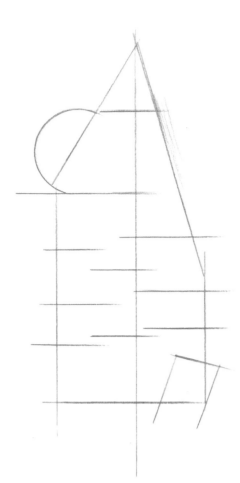
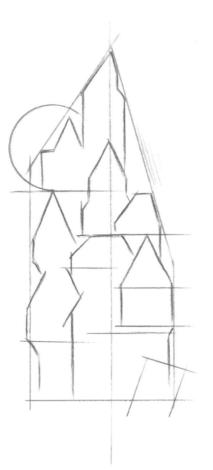

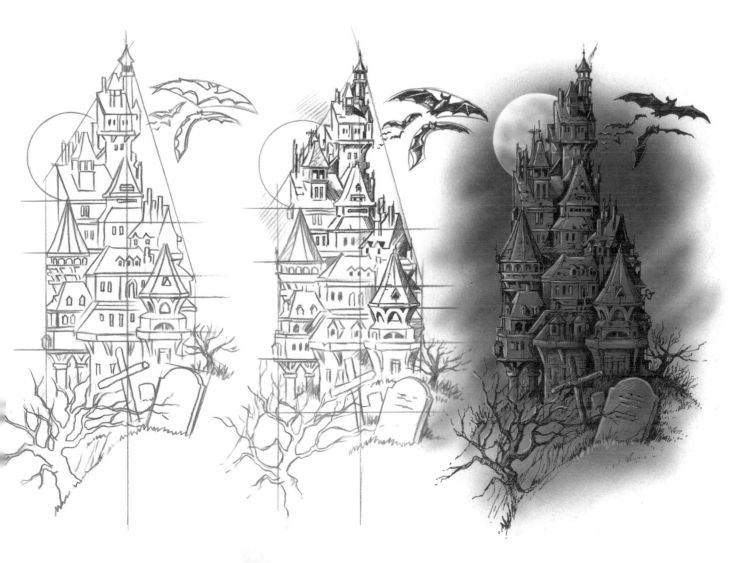

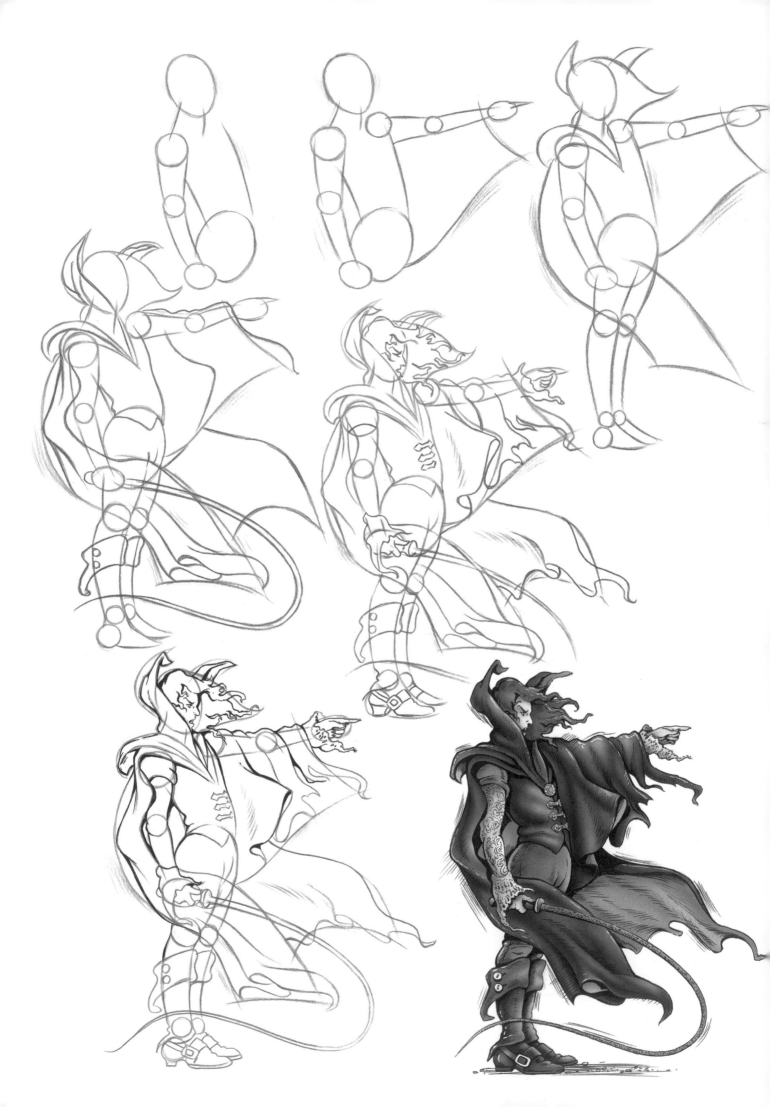

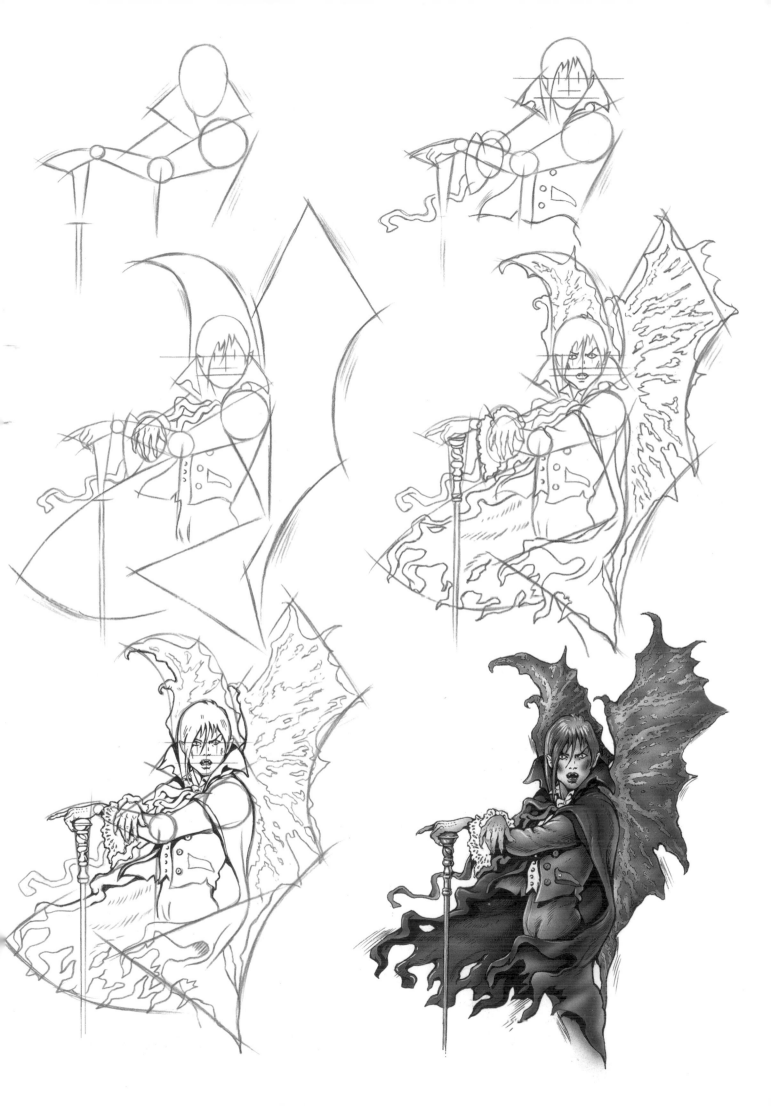

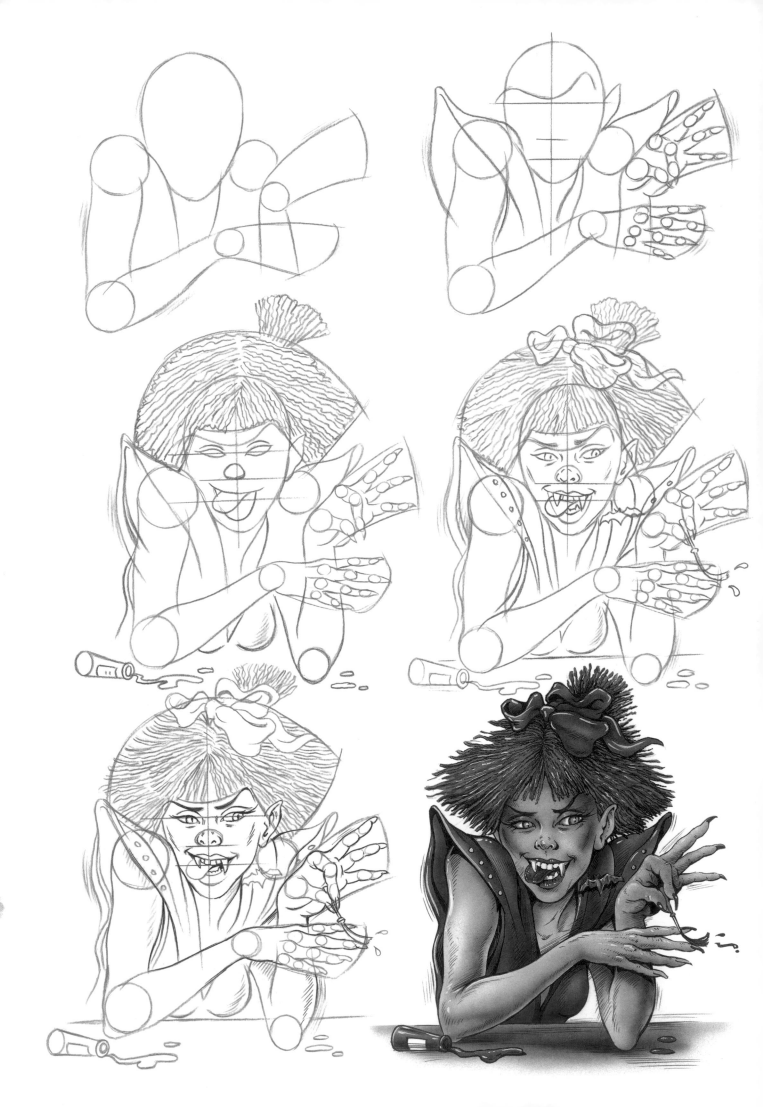

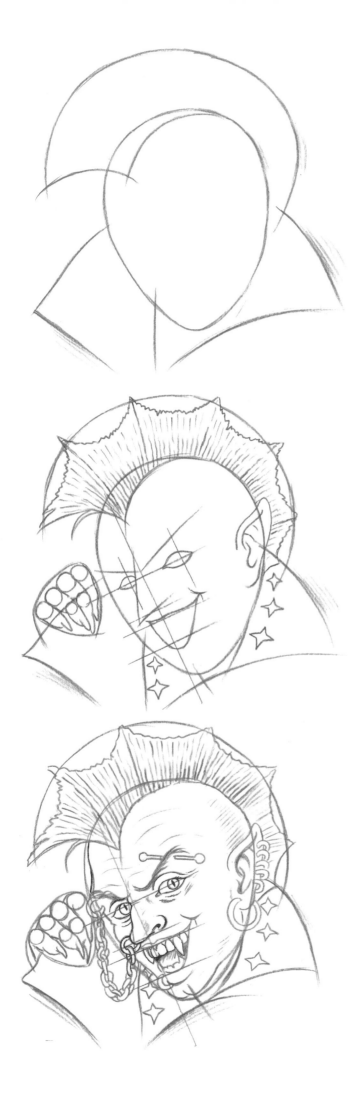
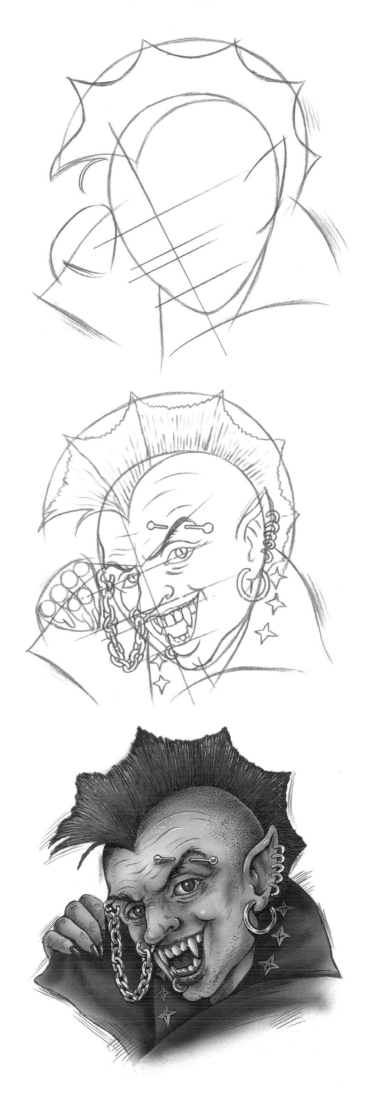

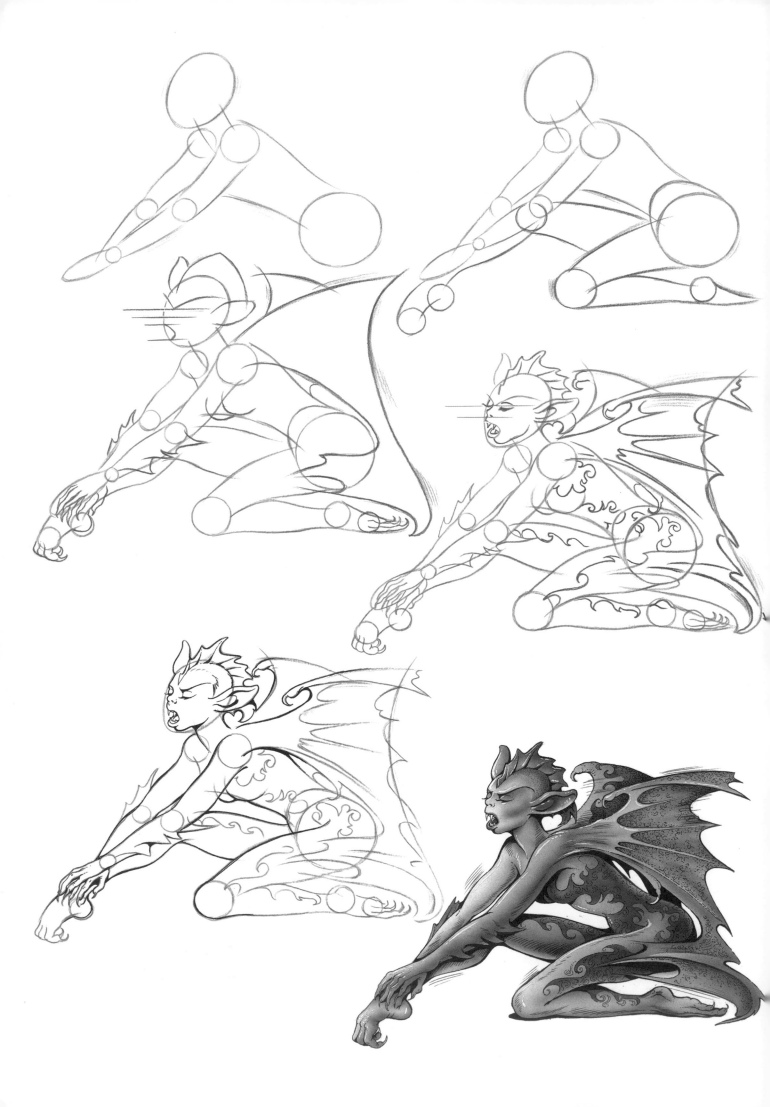

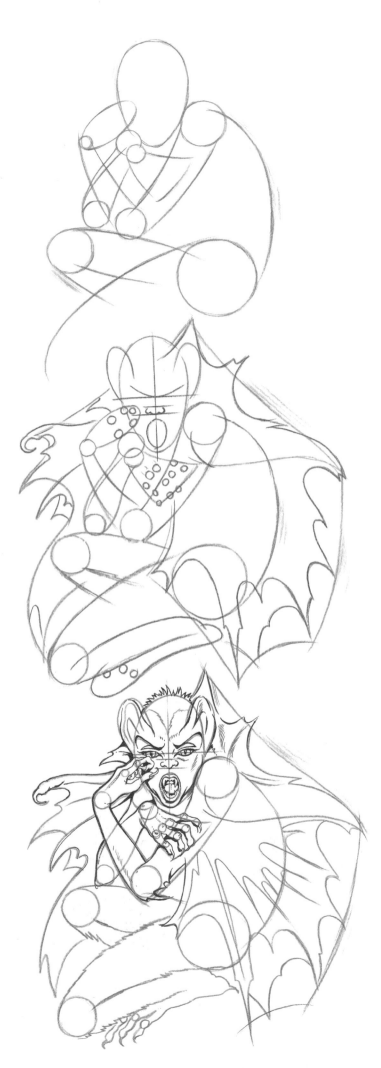
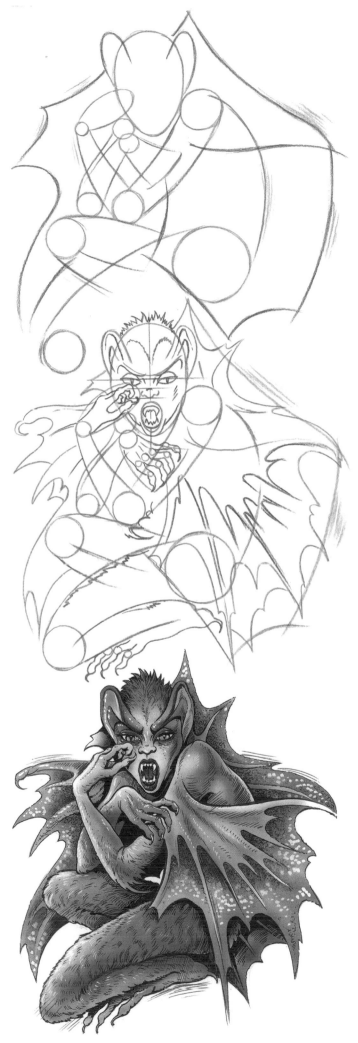

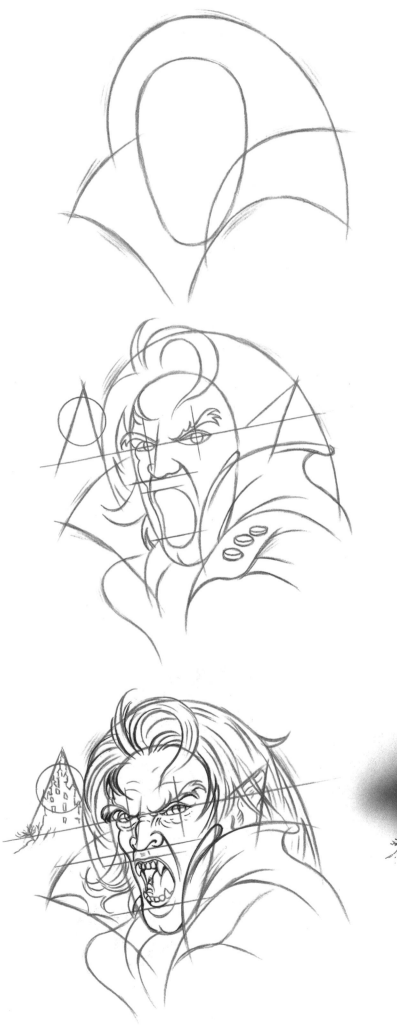
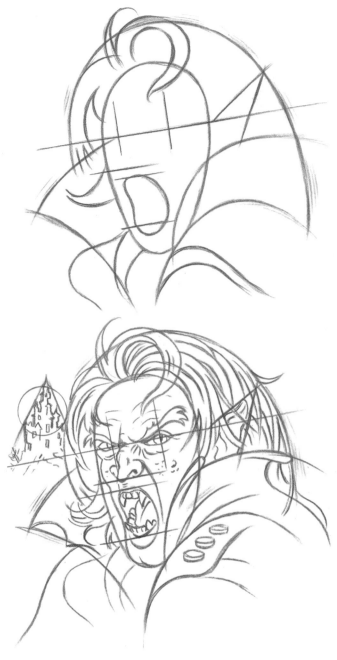
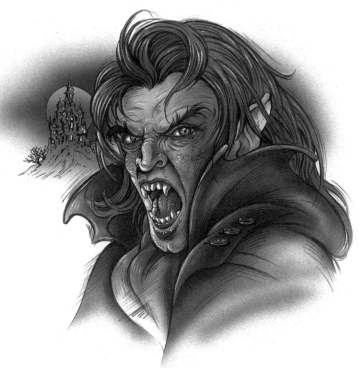

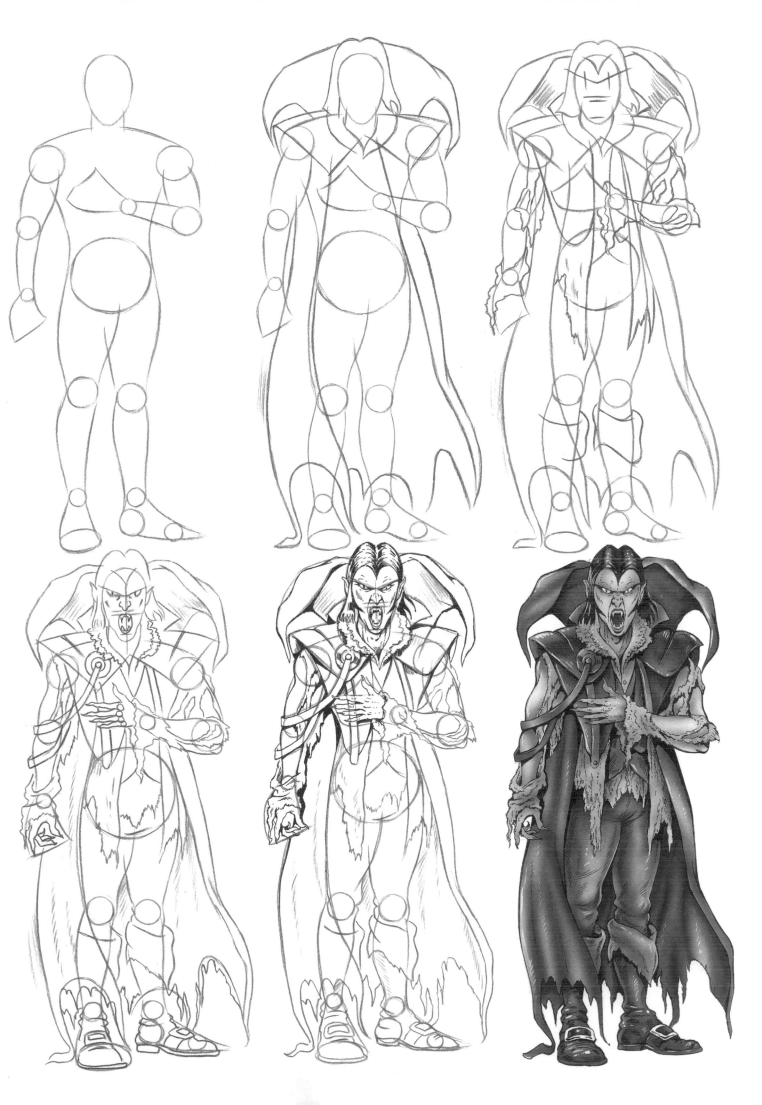

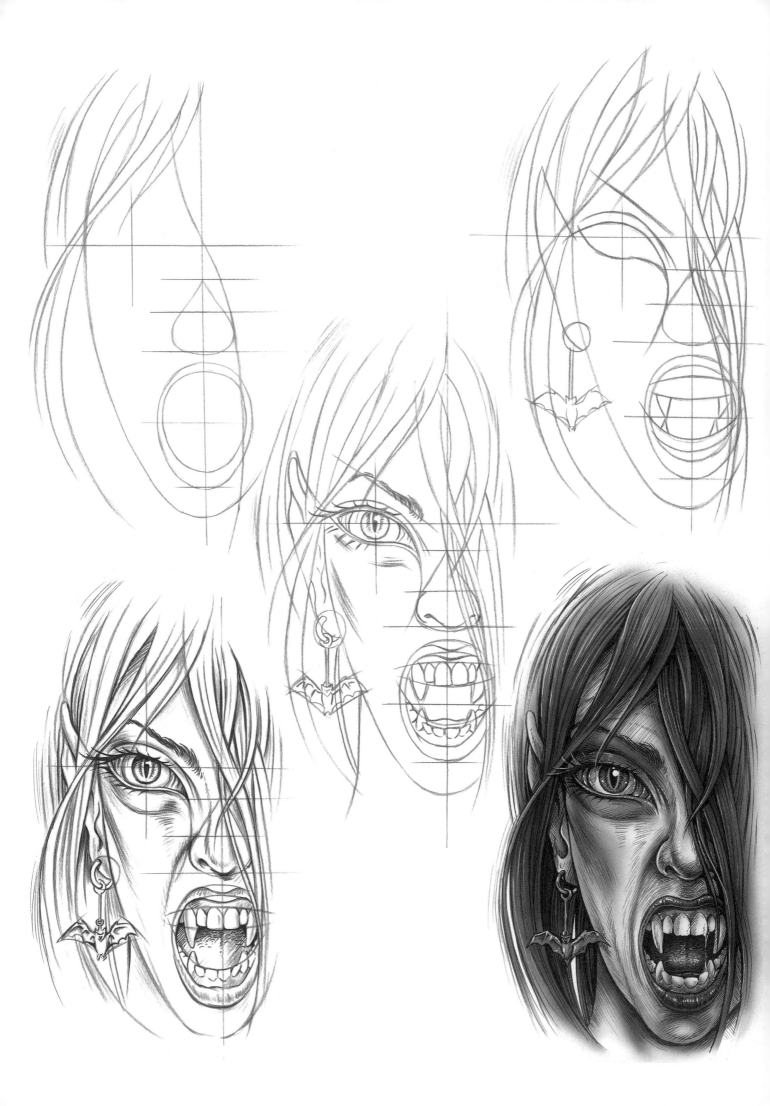

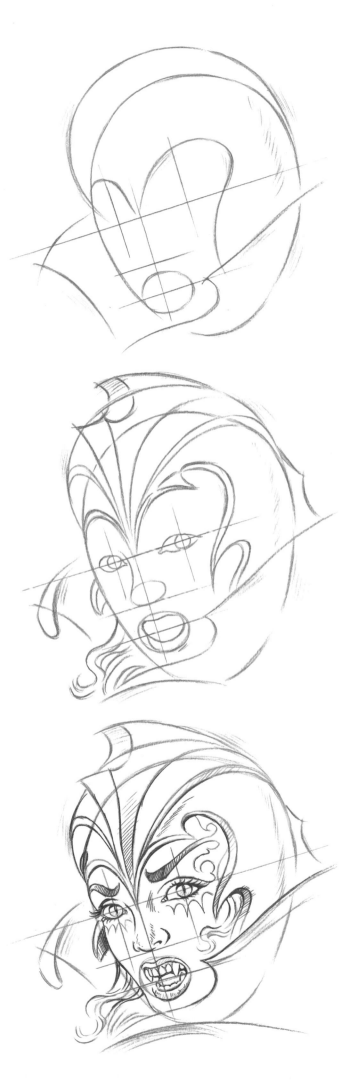
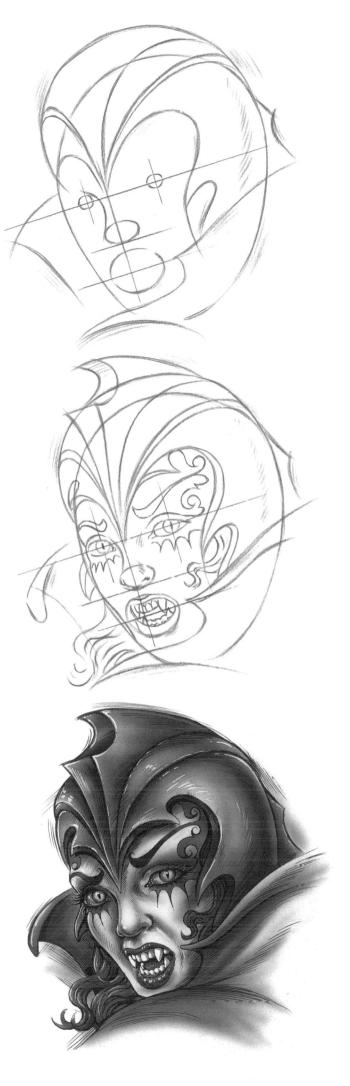

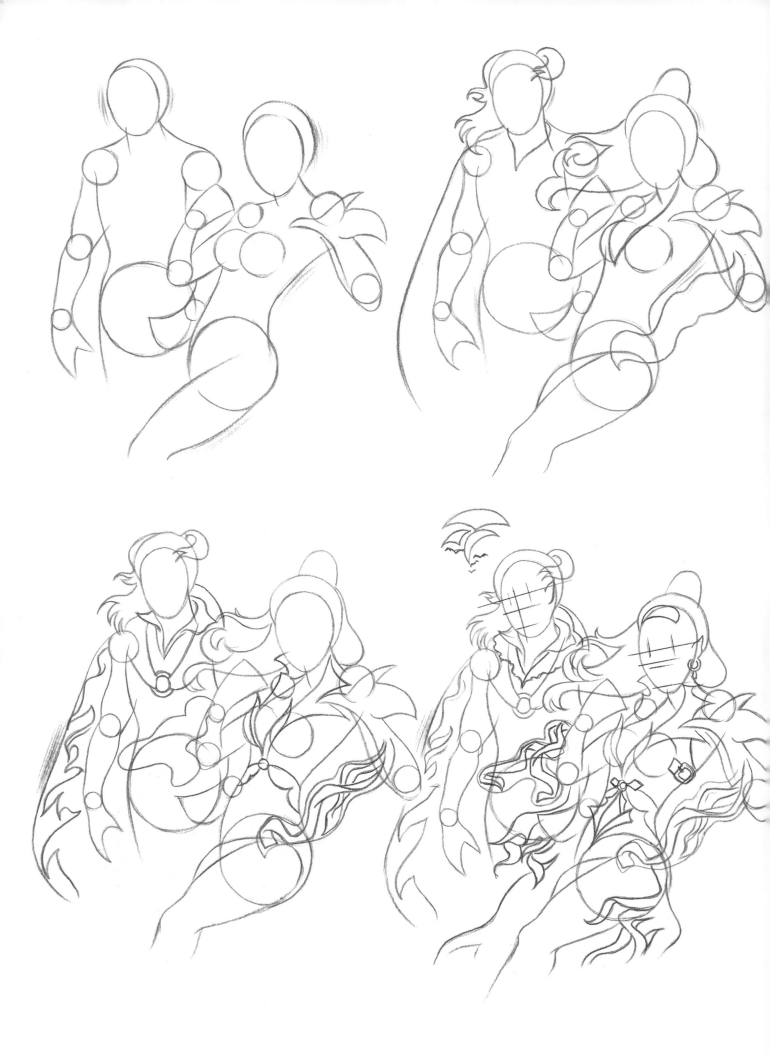

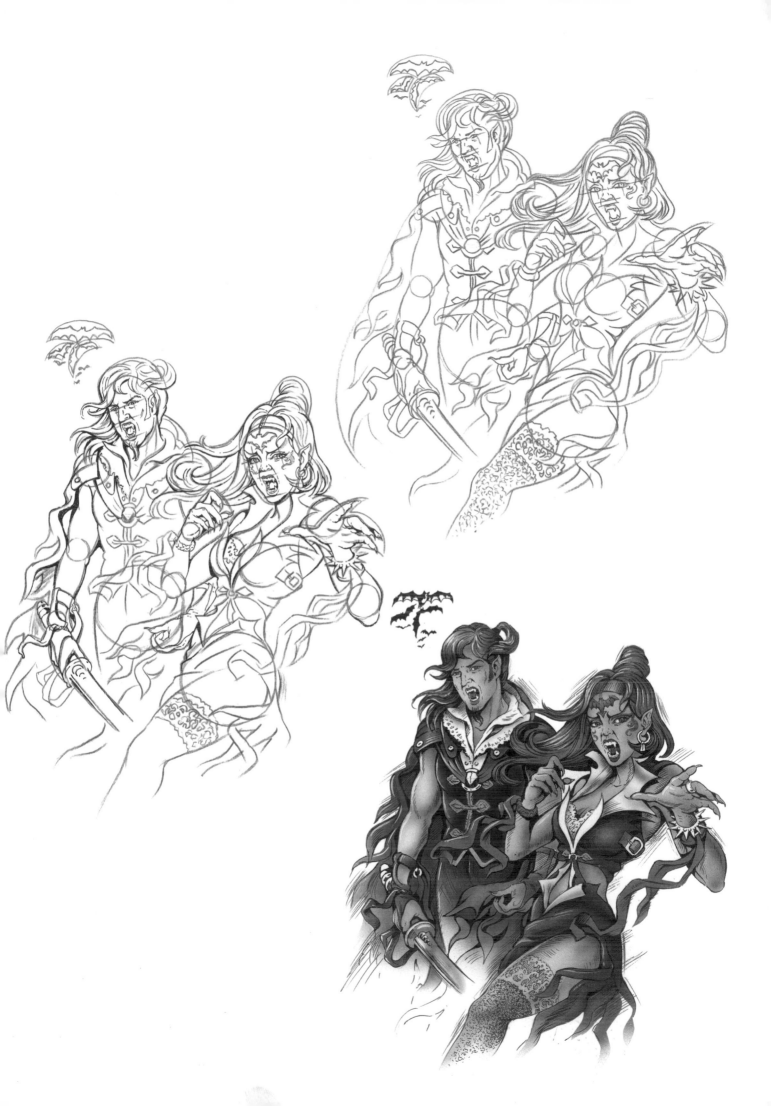

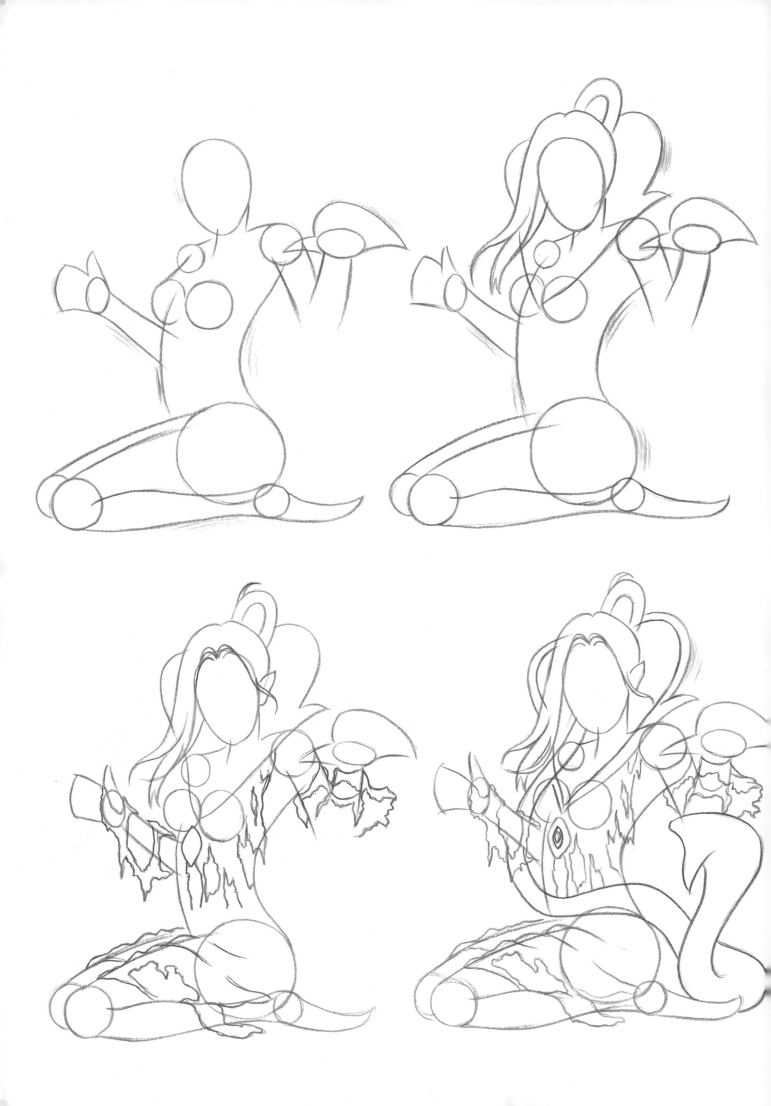

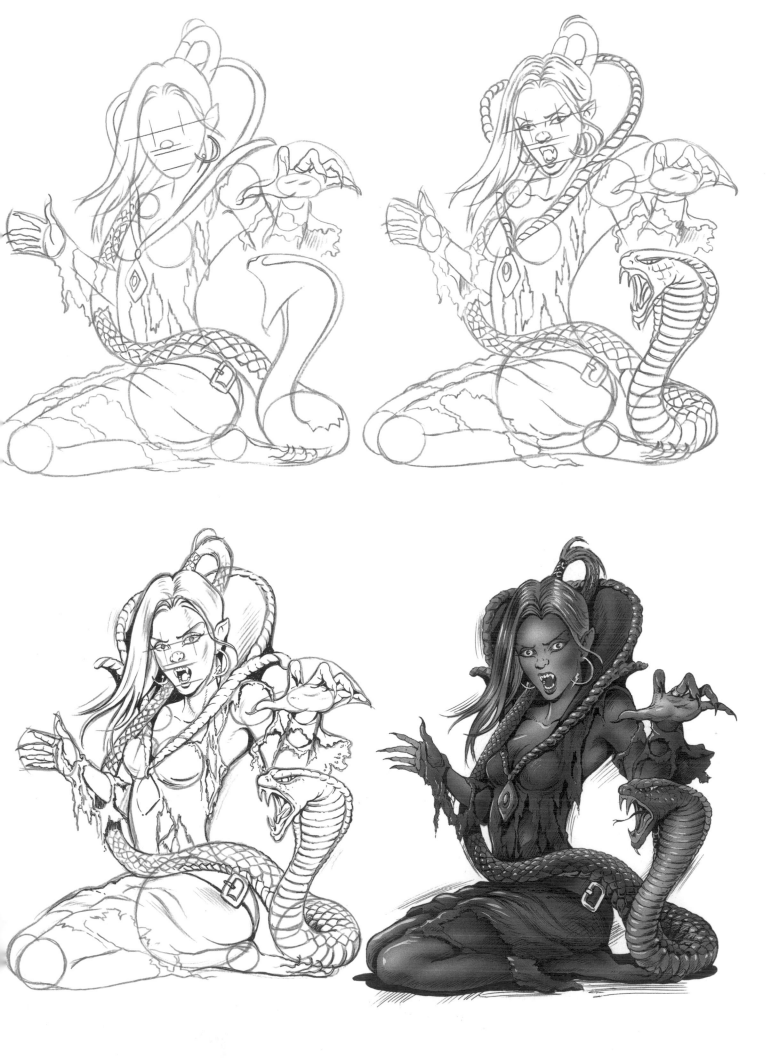

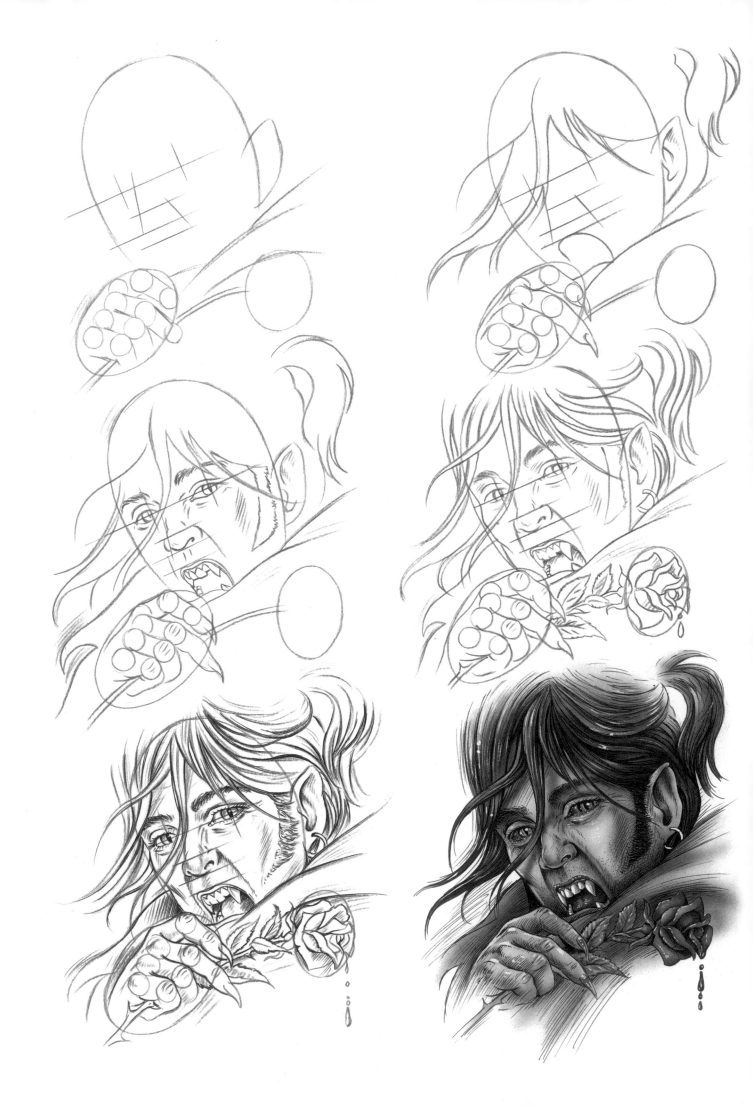

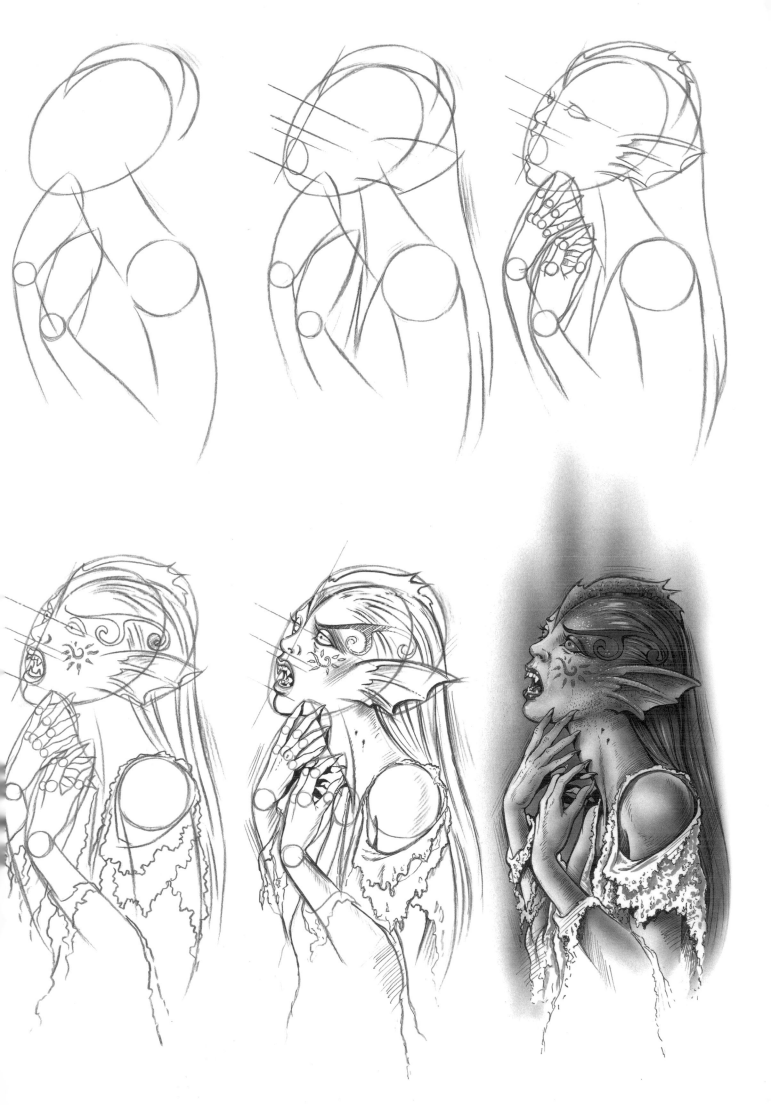

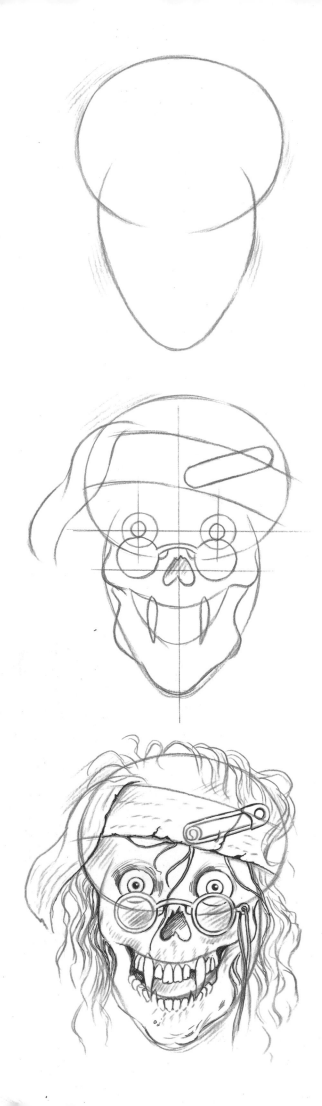
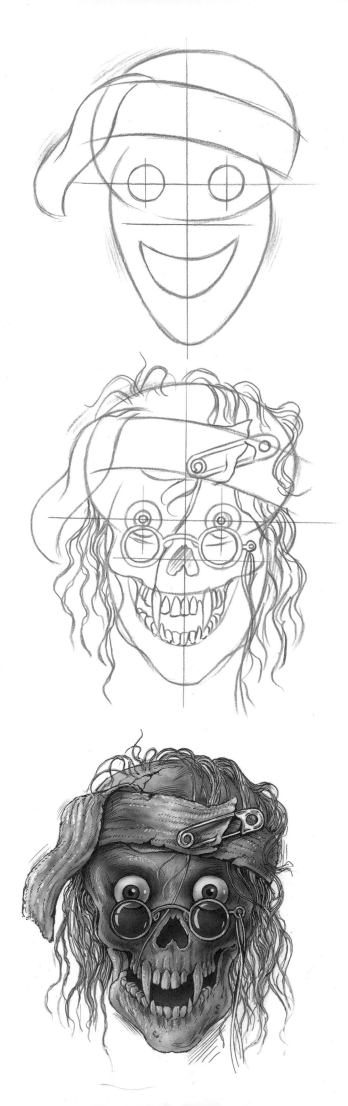